Unknown Rome

Francesca Brocchetta

UNKNOWN ROME

Copyright © 2019 Francesca Brocchetta

Tutti i diritti riservati.

Codice ISBN: 9781098701086

Preface

Countless volumes have been written about Rome, but a visit to any bookstore is enough to give one the feeling that, leafing through the pages of the various existing texts, it is impossible to truly absorb the spirit of that city. Like an elusive animal, a she-wolf, to take the archetypal image that has always been its symbol, you can watch Rome from a safe distance but never really catch hold of her.

Yes, Rome knows her own virtues, and lies there, sensual and lazy, draped along the banks of the muddy river we Romans call the blond Tiber, confident of her age-old charm.

It is ot easy to penetrate the centuries-thick shroud of history, but the journey I propose, and which we shall embark on together, hopes to do just that, taking an initiatory course which will allow us to capture on paper, for the first time, the soul of the city. On our travels we will reveal its secrets, its mysteries, all its dark sides, and those aspects that no scholar or art historian has ever ventured to investigate.

New York, Prague, and Turin are know the world over as magical cities, but we shall see how, in reality, alchemy, the paranormal, anything that can be considered "esoteric," is written in the DNA of this city more than any other. Bernini, Borromini, Della Porta, Piranesi, these are just a few of the artists who have painted a portrait of Rome. All these characters are linked by a lowest common denominator: their interest in the occult and alchemical practices, as well as their belonging to secret Masonic orders. One only has to look around to admire the signs they were interested in: churches, domes, squares, statues, and fountains, everything is imbued with a magical and

mysterious symbolism. In no other capital city is there hidden so much that is arcane and unknown.

A sunny and cosmopolitan city, but also sinister and mysterious, shut in its own enigmas; populated by demons and ghosts, magicians and occultists. The Pantheon fascinates so many tourists, yet so few of them know its true meaning. Are you ready to learn the truth?

Did you ever think you would find, right in the city center, hidden in a garden in one of the historic squares, an alchemical gateway able to teleport you to parallel worlds?

Are you ready? Let's go!

UNKNOWN ROME

CONTENUTI

1	Bernini the alchemist	1
2	The magic door and the alchemy circle of Villa Palombara	4
3	The Pantheon: gateway to the stars	7
4	Museum of the souls of purgatory	11
5	A place out of time	13
6	The hidden quarter	15
7	Borromini's secret message	17
8	Tiber Island: the realm of Asclepius	20
9	The Aventine Hill: the ship buried by the Templars	24
10	Where did Julius Caesar die?	27
11	The skeleton crypt?	29
12	Giordano Bruno	31
13	Michelangelo the heretic	33

1 BERNINI THE ALCHEMIST

It is well known that the people of Rome like to nickname everyone, even statues; but "Minerva's chick" really is a bizarre name to call the little stone elephant holding up the obelisk in one of the most beautiful squares behind the Pantheon.

The monument is opposite the medieval church Saint Mary above Minerva, which owes its name to the fact that it was built on the remains of a former temple dedicated to the goddess of wisdom.

But why does this statue deserve a special mention in a mystery tour? Just carry on reading to understand why.

In creating the elephant figure, Bernini drew his inspiration from one of the illustrated tables in the book Hypnerotomachia Poliphili by Francesco Colonna, a fifteenth-century romance which even today is considered one of the most mysterious books of all time.

Why did Bernini choose one of the enigmatic illustrations in the Hypnerotomachia as the model for his monument?

Could such a choice have been dictated by the need to hide within the city those initiatory symbols which would conceal the path of the Illuminati?

A web of mystery, religion, art, and esotericism shrouds Bernini's art. It is no mystery that he belonged, like Galileo Galilei, to the secret society of the Illuminati.

But who were the Illuminati?

They were mostly intellectuals who wanted to share their knowledge and hand it down to their successors.

Some say that this sort of cult, enemy of all religions, controls the governments of the world's most powerful nations and the banks to this day and is at the center of numerous international intrigues. But if all this is true, what did Bernini want to communicate to us through this work? Reality and fiction cross over continually in an intellectual game which we as spectators are also called upon to join in.

The inscriptions seem to recall precisely the ultimate goal of the Illuminati: the superiority of science over religion.

But let us take a closer look at what is rightly considered one of the most precious and most obscure texts of the Western world.

Hypnerotomachia: an invented word made up of the Greek terms hypnos (sleep), eros (love), and machia (fight) and meaning "a love battle in a dream." Poliphili is a Latin word meaning "of Poliphilo." The title, then, is literally "Poliphilo's love battle in a dream" and describes what the hero of the story does: he is seeking his beloved in a dream.

It is worth describing the pages of the book that deal with Poliphilo's dream encounter with the curious elephant that inspired Bernini.

At the beginning of his voyage, the hero meets a gigantic elephant made from sparkling and very hard stone. On its back is tied a saddle with a hieroglyphic-charged obelisk on top. At the tip of the obelisk is a ball. A breastplate hangs from the saddle bearing the inscription

"Cerebrum est in capite": "intellect is in the head"; and on its forehead a rectangular plate contains the words "labor and industry." The image alludes to the robust, well-balanced and prudent mind onto which divine wisdom is grafted, symbolized by the obelisk and its hieroglyphs.

It is no accident that the elephant is a symbol of patience, honesty, purity, intelligence, and mental poise, so much so that in Hinduism the god of Knowledge, Ganesha, is represented with the head of an elephant..

2 THE MAGIC DOOR AND THE ALCHEMY CIRCLE OF VILLA PALOMBARA

The magic door in Rome is Italy's only alchemical relic. Going back to 1870, in the tiny Saint Vitus street in Rome, a narrow and lonely street delimited on both sides by long, low, uniform walls interrupted by the occasional house, there was the marble frame of a door on the boundary wall of a garden. That doorframe usually aroused the curiosity of passersby since the doorstep, jambs, and architrave were all adorned with kabalistic signs and Latin and Hebrew inscriptions. It was said that it was the entryway to the gardens of a mansion which had belonged to a marquis, an alchemist who had formerly tried to produce gold by extracting it from solidified urine. After the mansion and the boundary wall of its garden were demolished, the door was taken apart in 1873 and taken to where it can still be seen today, in the gardens of Piazza Vittorio Emanuele.

But what are the origins of the door and who built it?

To answer this question we need to take a step back in time and meet one of the most fascinating and mysterious

figures Rome has ever known: the marquis Massimiliano Palombara. Lover of alchemy as he was, he built a laboratory in the first floor of his mansion where he summoned the most illustrious alchemists of his day. He created nothing less than an alchemy circle, attended by queen Christina of Sweden, philosophers and spiritualists, and famous alchemists such as Francesco Borri and Athanasius Kircher. Through the science of alchemy, these men hoped to transform base materials into gold, the famous philosopher's stone. This apparently material process conceals a procedure of spiritual and inner refinement through symbols and arcane expressions decipherable only by initiates.

It was a long and difficult process to arrive at the philosopher's stone: practitioners had to keep it hidden, and they also had to hide the results of their endless and laborious research from outsiders. So, in order not to forget the discoveries they had made, they used the cunning ploy of describing them by veiling them.

But who designed the door?

Legend has it that one evening a pilgrim presented himself at the Marquis's palace with a bouquet of mysterious herbs whose names he never revealed, used to produce gold, and declaring that he was able to carry out the sought-after formula. During his travels in the East he had discovered particular secrets which he would never reveal to anyone. The marquis, fascinated by alchemy and esotericism, did not hesitate for a moment to invite this curious character to stay. The next morning, however, the pilgrim had vanished into thin air, leaving behind a few particles of gold and a mysterious piece of paper covered in enigmas and magical symbols. The marquis of Palombara thus had the contents of the manuscript carved on the entrance door to the gardens of his mansion (the only door opening out onto the street and so visible to the most people), in the hope that one day someone would

manage to decipher it. On the doorstep is carved the interesting motto SI SEDES NON IS, which can be read from left to right, "if you sit down you will not go on," but also from right to left (SI NON SEDES IS), with the opposite meaning: "if you do not sit down you will go on;" irrespective of the direction, the moral teaches us to persevere on our path.

This phrase has an important esoteric meaning: if you take a rest, you will never get ahead, and if you are active you will go a long way.

The door is still there, exactly as it was carved and thought up by the marquis, looked over by the cats of the gardens of Piazza Vittorio where it awaits someone to read and understand it.

3 THE PANTHEON: GATEWAY TO THE STARS

The history of the Pantheon is tied in with supernatural occurrences right from its very beginning. The Temple of all the Gods, dedicated to the seven planetary divinities (Apollo, Diana, Jupiter, Mars, Mercury, Saturn, and Venus, whose statues were positioned in niches inside), came into being following a vision which the prefect Marcus Vipsanius Agrippa had before leading the Roman army into Persia.

The original dedication on the building confirms this theory: M•AGRIPPA•L•F•COS•TERTIVM•FECIT: "Marcus Agrippa, son of Lucius, consul for the third time, built."

According to legend, it was built in 27 BC following the apparition of the goddess Cybele, who asked Agrippa to build a Temple for which she herself would provide the architectural design! Cybele was for the pagans what the Virgin Mary is to Catholics, that archetype of a great universal mother who transcends religion and time. Indeed, visions of Mary are also often followed by the erection of sanctuaries and churches.

The Pantheon is visible from far away thanks to its enormous dome, the largest masonry dome ever built, whose supporting walls are over 6 meters thick. Yet, despite the impressive dimensions, the dome's proportions are so accurate that a perfect sphere would fit into it exactly.

The architect Le Corbusier, after seeing the Pantheon, said: "it's a moving machine," almost as if to underline the fact that not a single structural element could demonstrate a better balance between function and form.

The Pantheon was conceived as a celestial sphere. In this sphere the gods lived in eternity and the cornice dividing the rotunda from the vault of the dome is comparable to the celestial equator, in which the opening at the top is the Sun which, at midday during the equinoxes, projects a ray of light which crosses the cornice itself, just as it crosses the celestial equator on that day. Considering that the roof of the building represents the dome of heaven, where the Romans believed the gods resided, with the marking of the equinoxes, the temple had the symbolic function of elevating the emperors venerated here to the realm of the gods.

Standing under the dome gives one a feeling of embarrassment and emotion as if a direct spotlight had been shone from heaven to search every corner of one's soul. Looking at the center where the oculus (the opening at the center of the dome) is, it is hard not to see it as an actual gateway leading to an otherworldly dimension. The Pantheon, like many other pagan temples, was converted into a church with the advent of Christianity. In AD 608 it was donated by the emperor Phocas to Pope Boniface IV who, on May 13th the next year, dedicated it to the Virgin Mary and all the saints, and laid the bones of a large number of martyrs there which had been gathered from the catacombs. It was then renamed "Sancta Maria ad Martyres."

The consecration ceremony was ever so solemn, to the

tune of the Gloria, as the Catholic prelates entered the Pantheon for the first time. And then the Romans fancied that they saw seven demons fly up and flee away terrified, seven like the seven pagan divinities that previously inhabited the temple.

Today, where the seven planetary divinities once stood, lie the earthly remains of such illustrious characters as Raphael and several kings of Italy: Victor Emanuel II, Umberto I and Margherita of Savoy. According to a popular legend, the ghost of Umberto I, who was assassinated, turns up here on certain occasions! One time was in the '30s, when a guard was approached by the ghost who entrusted him with a message, which has remained secret, and as a "reminder" left him a fiery stripe on the sleeve of his uniform.

The Pantheon has given rise to many popular beliefs, mostly the fruit of superstition and religious obscurantism connected with physical manifestations of evil. A particularly curious belief is that the opening at the top of the dome did not initially exist but was created when a hefty devil, fleeing through the roof, knocked out the gilded apex with his horns. The golden artifact is said to have fallen onto the square behind the monument, giving it its name of Piazza della Pigna (pigna, as well as "pinecone," means "apex" in Italian).

No less medieval and diabolical is the legend about the origins of the ditch that runs around the monument. The inhabitants of Rome, having erased the memory of the "Saepta Iulia" (a four-sided portico which stood to the left of the Pantheon, the remains of which, due to the ground level being raised, form a sort of ditch), call into play the devil once again. The legend would have it that Pietro Bailardo, a very famous sorcerer in Rome, traded his soul with Satan in exchange for the Libro del Comando, the supreme and secret manual of the black arts. A sort of Roman Faust who, regretting the unholy pact, used the arts he had learned in the magic book to fly on a

pilgrimage to Jerusalem and back to Rome in a single day. But he found Satan waiting for him at the Pantheon, claiming his soul according to their agreement. The magician, however, knowing how much devils enjoy walnuts, offered him some to eat. The evil one was distracted and Bailardo managed to save himself by taking refuge in the temple, where he prayed, sincerely repentant. At that point the devil, enraged at having been cheated in such a way, started circling the temple furiously, creating the ditch with his hooves. After all these centuries he should have gone by now.

4 MUSEUM OF THE SOULS OF PURGATORY

Is it possible to communicate with the dead?

It is hard to answer such a question. There are certainly places that demonstrate the existence of a territory halfway between the living and the dead. Are you ready to visit one of these places, well hidden and camouflaged in the chaos of the city?

It is a strange place, adjoining one of the capital city's few neo-gothic churches. The origins of the church go back to a fire in 1897 in the Chapel of the Madonna del Rosario (a private chapel built in the garden of a mansion).

After the fire the owners were alarmed and frightened by what they thought they saw, and they called Victor Jouet, a missionary from Marseilles, who seemed to recognize the face of a suffering person in the black marks the fire had left on the wall. Since then other similar phenomena have occurred. The priest interpreted them as souls from purgatory attempting to get in contact with the living, and decided to erect a church right on the spot where the fire had started.

The church of Sacro Cuore di Gesù fascinates drivers

and passersby as they whiz past on the road running along the Tiber, captured by that style thick with spires and strange representations. But very few of them imagine that the choice of gothic architecture was determined by limitations of space in the location where the church was to be built.

Inside the sacristy is a small museum which gathers together evidence of this existence and earthly passage as apparitions, scorch marks on books, clothing, etc.

Here you can see the traces of fire left by the souls of purgatory on prayer books, missals and textiles. You can also see a cross perfectly drawn by a fiery fingertip. To look at them it seems obvious that they could only have been produced by the spiritual "fire" that surrounds the souls of purgatory.

5 A PLACE OUT OF TIME

Today's world is too fast for the romantic tourist who wants to nourish his or her soul with timeless beauty.

One of the places I recommend you visit and that I am sure will caress your spirit is the Cimitero Acattolico, or the Protestant cemetery, or simply Testaccio graveyard, which is behind the Pyramid of Cestius.

As in a dream, we leave behind us the frenetic madness of the city and pass over to the other side. We almost expect a kind Charon to arrive and ask us for our passports: we have entered another country and we no longer know which language to speak. We take with us the verses of poets such as John Keats, Percy Bysshe Shelley and Pier Paolo Pasolini, who have all found their final resting place here.

We immerse ourselves in a sweet shipwreck of memories which find fertile ground in the levity of John Keats' epitaph:

"This grave contains all that was mortal, of a YOUNG ENGLISH POET, who on his death bed, in the bitterness of his heart, at the malicious power of his enemies, desired these words to be engraven on his tombstone: Here lies One Whose Name was writ in Water."

The cemetery tells a tormentingly romantic story... The Angel of Grief is the last work created by American sculptor William Wetmore Story, born in Salem, Massachusetts, in 1819 and living in Italy from 1848. The tombstone is in memory of his beloved wife Emelyn. He finished it shortly before his death, and Story is buried together with his wife and their small son Joseph.

The angel kneels before a pedestal, with its head leaning on its arm as it cries, hiding its face. Its hand hangs impotent over the front of the pedestal, and the curvature of the fingers, reproduced in such detail, lends the sculpture an incredible feeling of sadness and emptiness. A few stone flowers are scattered at the base of the pedestal, as if the angel had dropped them in the grip of pain at a difficult moment. The wings, too, which would normally be held aloft, straight and proud, are sorrowfully curved over the back, giving the impression of lost hope. The angel's body is completely abandoned to its pain and the feeling the piece transmits is one of heartrending humanity.

The remarkable realism of this image has made it famous, and it is no surprise that it has become the model for many a copied tombstone all over the world, especially popular in the United States.

An enchanted place rich in imagination and charm, where many swear they have seen and heard ghosts. Shelley and Keats, the two famous English poets joined by friendship, shared a tragic fate in Italy, only to meet up again in Rome, buried nearby one another. Many witnesses claim to have heard the two poets' verses recited in English in the middle of the night. Some swear that they have seen their spirits wandering amongst the cypresses.

6 THE HIDDEN QUARTER

At the intersection of Via Chiana and Via Tagliamento is a quarter shrouded in mystery which seems hidden from the gaze of passersby, concealing its magnificently surreal climate. The sharp-eyed observer can manage to penetrate the veil which the quarter seems to have thrown up to protect itself simply by raising his or her eyes. There you can lose yourself amidst medieval towers, baroque crests, decorations with a retro taste. Like novice Alices in Wonderland, you find yourself in a fantastic place beyond time, a refuge for the imagination. This picturesque area is situated a stone's throw from the city center, enriching one of the capital's most elegant zones and, at the same time, breaking the architectural routine. Seventeen villas and twenty-six palaces along Via Tagliamento and Piazza Buenos Aires make up the Quartiere Coppedè, named after the Florentine architect-sculptor Gino Coppedè who designed it between 1913 and 1921.

The Quarter opens triumphantly with the majestic and somewhat somber entrance arch which joins two palaces and where Renaissance, Gothic and Baroque symbolism and elements merge together to create a sort of suspension

of time. Further undermining the sense of time and reality is an enormous wrought-iron lamp immediately below the arch.

Following Via Brenta we arrive at the beating heart of the quarter: Piazza Mincio, the film set for many Italian and foreign horror films. Right in the middle of the square is the "Frog Fountain," Fontana delle Rane, famous for the images of the Beatles bathing in it, fully clothed, after holding a concert in the nearby Piper disco. The fountain is positioned in such a way that the abovementioned lamp and the House of the Fairies, another characteristic element of the building complex, can be seen from it.

The neo-gothic magic the buildings evoke, and their spectral appearance at night, has inspired more than one film. Faithfully reconstructed in the set of Cabiria, the Coppedè quarter bewitched horror director Dario Argento, who made it the location of two of his most famous feature films, Inferno and The Bird with the Crystal Plumage.

The eeriness and mystery of the place is all the more for its architect's strange suicide. He was only fifty years old when he died, leaving many unfinished works and a whiff of Satanism that, according to some schools of thought, is the key to understanding many of his eccentric works. Perhaps that is why a popular belief suggests that this place, these piazzas, are a meeting place for witches.

7 BORROMINI'S SECRET MESSAGE

There is one dome in Rome that can be seen from the panoramic views over the city and which never passes unobserved, arousing the curiosity of those who do not know the city well.

It belongs to a church which is rarely visited due to its slightly concealed location, albeit right in the city center. A stone's throw from Piazza Navona and Palazzo Madama, headquarters of the Italian Senate, on Corso Rinascimento, is the entrance to the courtyard of the sixteenth-century building of La Sapienza, Rome's ancient university, founded by Pope Boniface VIII in 1303. It was in use until 1935, when the university city was inaugurated. At the end of the courtyard is the church of Saint Ivo which acted as a chapel to the ancient Roman university.

This construction is considered the highest expression of Borromini's genius, as well as, for many, the best that baroque has given to the world. Borromini was an architect known for the strength and complexity of his abstruse and symbolic thought, which is always reflected in his works. It is no accident that he has been described by many as the occult architect of the baroque.

Extremely dynamic and lively, the interior of the church was structured on a ground plan based on Solomon's seal, made up of two intersecting equilateral triangles forming a six-pointed star. An undulation is then created on this base by alternating concave and convex walls to move the points of the seal in and out.

A unique spiraled dome creates an unbearable feeling of respiratory oppression in whoever goes inside, as if they were entering a state of trance. This splendid invention of Borromini, which soars resolutely towards the sky, has been the object of unending debate among scholars concerning the symbolism hidden within it.

On the subject of religious symbolism, it could be said that the great Swiss architect may plausibly have been inspired by the spiral iconography of the Tower of Babel or the Lighthouse of Alexandria, as if the church acted as a beacon to the faithful: in fact on the top of the dome are sculpted stone "flames," representing the fire which illuminates the Christian way.

Making connections between some of the symbolic elements of the dome and the church's interior, we can trace a further interpretation of Borromini's message.

As well as the Tower of Babel and the Lighthouse of Alexandria, the spiral dome also recalls another legendary place: the Delphic Oracle, once considered the navel of the known world. Apollo was patron of Delphi. It is interesting to discover inside the church a representation of an angel, in the foreground drawing our attention, shown wearing a laurel wreath and whose face is unlike the others, recalling the features of the Greek god. By depicting the Oracle at Delphi, was Borromini trying to establish a new navel of the world in Rome?

But that is not all.

The vault of the church is covered with four- and six-winged angels. Is this simply an artistic quirk or does it

hide something else? The book Celestial Hierarchy by Pseudo-Dionysius the Areopagite tells us that not all angels are alike. Those closer to God, the Seraphim (fiery beings), burn with divine love which they transmit to their subordinates, the Spirits. To protect themselves from the fire of the divine light, they have more wings (six, to be exact) than the angels further away and thus less burned by the heat. With two wings they cover their faces, with two their feet, and the last pair are used for flying.

It is clear, then, that the vault represents an initiatory ladder towards heaven, towards the divine light, also understood as wisdom.

Talking of "wisdom"... when you go out through the back door onto Piazza S. Eustachio, next to the right-hand colonnade, you can see below the balcony a rebus thought up by Borromini himself.

The strangest thing about it is a serpent looking in a mirror.

Here the serpent does not have the usual negative connotations... as well as the image of the serpent with the apple, there is, of course, the figure of the snake as a symbol of knowledge. Jesus himself said: "Be ye as wise as serpents and as innocent as doves."

I interpret the rebus in the sense of knowledge reflecting itself. Knowledge squared is none other than wisdom.

8 TIBER ISLAND: THE REALM OF ASCLEPIUS

Tiber Island is one of the most picturesque and intense places in Rome. Legend has it that the island has always been connected with the god of healing, or rather vis medicatrix naturae, the healing power of nature, Asclepius. According to this branch of medicine, which is considered "alternative" today, healing is not so much the result of the doctor's efforts, but is rather due to nature's own self-repair.

Legend has it that when the last king of Rome, Lucius Tarquinius Superbus, was overthrown in 509 BC, the people tried to destroy his enormous grain stores by throwing them in the river, but they were so abundant that they ended up forming a small island.

Later, in 293 BC, when Rome was struck by an epidemic that could not be eradicated, the Romans consulted the Sibylline Books (or the Delphic Oracle, according to Ovid's Metamorphosis) to find out how to escape the scourge. The answer was that the god Asclepius should be brought from his most important sanctuary, at

Epidaurus, to Rome. So a delegation was sent by sea, with the task of asking for the god (or, to be more precise, his religious image). But while the negotiations were underway, the god himself appeared in the form of a giant snake which boarded the Roman ship of its own free will. The Romans then set sail for home and, favored by extraordinary winds, they arrived at the mouth of the Tiber after stopping off only once on the way. They were welcomed by jubilant crowds, and when the ship sailed upriver to the city the divine snake climbed the main mast and looked around; he then slithered out of the ship and landed on Tiber Island, where a temple was built to him.

Many people sought the god's help (or rather the help of his therapist priests), as inscriptions and the numerous votive tablets discovered under the Tiber between 1885 and 1887 during riverbed works bear witness to. These tablets were mainly used by the humblest classes (freedmen and slaves). Since the cruel habit of abandoning sick slaves on Tiber Island whose upkeep had become too expensive for their owners was becoming more and more widespread, the emperor Claudius ordered that every slave abandoned, if he could be healed, could consider himself free, with no obligation to return under the authority of his owner.

In memory of its foundation legend, the island was giving a travertine facing in the shape of a ship – strangely enough, though, not with the bow facing against the current, as one might expect based on the legend, but facing towards the sea, almost as if Asclepius's ship were lying at anchor, so to speak. Remains of this monumental work are still visible; in particular the back end, on the side of which we find a ram's-head decoration of the type formerly used to protect the sides of the ship as it was docking. At the front a well known symbol of the god can be seen, one which is still used as the emblem of doctors

and pharmacists to this day: a serpent entwined around Hermes's staff.

The main mast of Asclepius's ship, from which the serpent, on his arrival, spotted the site where his temple would stand, was also symbolically represented on the island: an obelisk placed at the center of the island, whose foundations were discovered in 1676. It is thought that this obelisk was hidden in the basement of the church of St. Bartholomew, built on the ruins of the ancient temple.

The island's medical traditions, linked to the cult of Asclepius, did not die out. At the beginning of the Middle Ages, when the temple already lay in ruins, Tiber Island became a refuge where the sick were treated, run by monks. This popular institution was gradually transformed into a proper hospital, Fatebenefratelli hospital, founded in 1584 and in use to this day.

The island is anchored to the mainland by two ancient Roman bridges; in fact it was originally called insula inter duos pontes "the island between two bridges."

On the western side Cestius's Bridge connects the island with the Trastevere quarter. Built in the late 1st century BC, it was named after Lucius Cestius, civil administrator and brother of Gaius Cestius, more famous for being buried in the celebrated pyramid at St. Paul's Gate.

Damaged by flooding on various occasions since, in 1849, during the siege of Rome by French troops, the bridge was deliberately destroyed on Garibaldi's orders for defensive purposes.

At the end of that century it was entirely rebuilt using the original fragments, but the shape of the bridge was changed to accommodate the new defensive walls along the banks of the river.

On the eastern side of the island, Ponte Fabrizio joins the mainland in the Ripa quarter, the quarter the island

itself is part of. It was built in 62 BC and is therefore a little older than Cestius's Bridge: this earns it the record for the oldest historical bridge within the city limits and second only to Ponte Milvio in greater Rome, although this latter bridge was once outside the city, 2.5 km from the most southerly gate of the city walls.

Lucius Fabricius was curator viarum and was therefore in charge of the city's streets; his name is carved in large letters on the cornice of the bridge's arch.

Nonetheless, the people of Rome more often call it Ponte Quattro Capi "bridge of the four heads," due to two four-headed sculptures, one on each side, marking the entrance to the bridge. They date to Roman times but are not part of the original structure: they were placed here at the end of the 16th century, under Pope Sixtus V, during restoration works.

According to popular legend, these heads are the heads of the architects the pope had charged with restoring the bridge. They could never agree amongst themselves and were always arguing. Sixtus V, annoyed by such disgraceful behavior, had them beheaded. But since the bridge had been restored well, he recognized their good work by placing their images on it.

There is another bridge visible from Tiber Island. This is Pons Aemilius (179 BC), also known as Ponte Rotto, "broken bridge." It was damaged several times when the river was in flood. It was rebuilt for the umpteenth time between 1573 and 1575 (the date visible on the stone built into the surviving arch) under pope Gregory XIII by architect Matteo di Castello. The great flood of 1598 swept away three of the six spans and the bridge was never rebuilt, hence its current nickname.

9 THE AVENTINE HILL: THE SHIP BURIED BY THE TEMPLARS

The church of Saint Prisca, with its splendid Mithraeum, the romantic Orange Garden and the curious view of the dome of Saint Peter's which can be enjoyed through the keyhole of the entrance gate into the villa of the Knights of Malta, are only a few of the gems this splendid hill has to offer.

The Aventine Hill really is one great feast for the eyes and for research into symbolism. Of all of Rome's seven hills, this is the one with the most mystical atmosphere, probably because it has demonstrated its religious vocation since ancient times, from ancient cults surrounding the mysteries of Isis and Mithras to early Christianity and the mysterious Order of the Knights of Malta. Here enchantment and dreams are at home: you just need the right sensitivity to perceive them.

This hill, which witnessed the rise and fall of the knightly order central to esoteric culture, offers certainly one of the most picturesque walks you can go on in Rome.

The year is 1312. The Order of the Templars is suppressed. With the suppression of the Order and the extermination of the Templars by Philip the Fair, their Roman and European possessions pass to the Knights of Rhodes, heirs to the traditions of the Knights Hospitalers. Thus a small church on the Aventine Hill (the church of Saint Mary of the Priory) belonging to the Templars became the property of the Knights of Rhodes. In 1522 the Knights of Rhodes changed their name to become the Sovereign Order of Malta. In 1765, the renovation of the church was entrusted to Giovan Battista Piranesi, engraver, architect, mason and esotericist.

When Piranesi was charged with the renovations of the preceding sixteenth-century building, he designed the project of the church almost as a secret code, and the façade became something like a hermetic text which only a few individuals were able to interpret. Indeed he used a rather varied repertory of elements only theoretically relatable to antiquity but in reality reinvented according to the symbolic meanings which were to be concealed. The decoration of the façade, which still preserves some elements of the preceding structure, was conceived in stucco (a material which simulates the more durable marble, but which is essentially ephemeral). Ephemeral like all the works of man. A metaphor of time then, and of all human action, perceptible to the masses, but more profoundly interpretable only by a few people.

But, above all, he decided to create something that would make visitors feel like pilgrims embarking on a Templar ship, ready to set sail for Jerusalem. Piranesi's passion for the occult gave rise to the legend that the complex was conceived as a vessel about to sail to the Holy Land: "in the middle of the night, one day, she will hoist anchor to arrive in the Holy Land," says one prophecy.

Indeed, the southern end of the hill, where it slopes down to the Tiber, is shaped like a gigantic letter V and constitutes the ship's bow; the labyrinths in the gardens symbolize the maze of rigging; the park's parapets are the battlements on the open bridge, and the forest of little obelisks in front of the church are the ship's masts.

An esoteric vision which ties up with a real event in the history of the Templars, after they were annihilated. The Order's naval fleet set sail from the port of La Rochelle, France, where it had been anchored, and nothing more is known of it. A legend has been grafted onto this fact, which tells that one of these ships, the richest and most powerful, was hidden within the Aventine Hill thanks to a powerful magic spell. It lies there awaiting the ancient knights' return, and a new spell that will free and set it sailing down the Tiber towards the Holy Land.

10 WHERE DID JULIUS CAESAR DIE?

Some apparently minor places of interest actually hold important historical information.

Julius Caesar died in Rome, in the heart of the Eternal City, in a very precise place.

But where?

One of ancient Rome's most intriguing detective stories. A mystery which has persisted for more than two thousand years: to be precise, since March 15th 44 BC, the famous Ides of March, when Julius Caesar was brutally assassinated, stabbed 23 times. We know who the assassins were, the conspirators and Decimus Brutus, who attacked him with such fury. What we don't know is where exactly Julius Caesar met his doom; but the answer may be close at hand.

What we do know is that he was not killed in the Senate, because it had been burnt down, nor in the Forum which is where he was cremated. The most credible hypothesis is that the dictator was killed in the Curia of Pompey, near the holy area of Largo di Torre Argentina, close to the statue that commemorated him, where Senate meetings were held. Part of this complex, which also included other buildings, can still be seen in Largo

Argentina.

Perhaps Caesar died near that part of the wall overlooking Campo de' Fiori in the Piazza dei Satiri area where Pompey's Theater has been found. Today, in this same spot we can admire a stunning ancient pine tree.

11 THE SKELETON CRYPT

In the catacombs of the church of Santa Maria della Concezione, in Via Veneto, right in the center of Rome, is a place at once macabre and mysterious: the cemetery of the Capuchin monks. Even though lots of tourists to the Eternal City visit this area, this place has preserved its charm intact for more than three centuries and jealously guards the mystery of death... and more.

The church looks like just another of the capital city's splendid baroque churches, but in its crypt is a unique "funerary monument" unlike anything else in the world. In this hidden place the Capuchins have buried the remains of their deceased brothers since the 16th century, accumulating an enormous quantity of bones and skulls.

Even the libertine and eccentric Marquis de Sade, on a visit to Rome in 1775, was shocked by this mosaic celebrating death.

Here, room after room where everything is built from the lined up, fitted together, overlaid, and nailed down bones of the thousands of Capuchin monks who lived, prayed, and died in the monastery on the upper levels (around 3700 people were buried there before 1870), have always inspired fascination and mystery in the imaginations of Rome's inhabitants and tourists, attracted by the celebration and representation of death.

In the middle of the skull crypt is a winged hourglass, symbol of our limited time on Earth, and below that are five skeletons dressed in the Capuchin habit, three in the act of walking and praying and two lying in niches, as a warning to live life constantly on the path of prayer before

death. Even though the decorative style is decidedly rococo, the meditation on death and the symbolism of the transience of worldly things is absolutely baroque, like the motto warning: "We were what you are, and what we are you will be."

Another interesting crypt is that of the skeletons. A homage to the powerful Barberini family, commissioners and patrons of the Capuchins of l'Immacolata: the three skeletons fixed to the walls and the winged skulls they hold in their hands are indeed those of members of the family. At the center, enclosed in an oval, is the skeleton known as "princess Barberini" holding a scythe and scales (all made from human bones), symbols of the inevitability and equality of death and the Final Judgment.

12 GIORDANO BRUNO

In February 1600 Giordano Bruno was burned at the stake as a heretic. Today, in Piazza Campo de' Fiori, where he met his end, is a monument celebrating him as a hero of freethinking, almost a forerunner of the proud laity of the end of the nineteenth century. But this is all one big misunderstanding. Giordano Bruno was opposed by the Church for very different reasons, as a proponent of a radically anti-Christian philosophy in which natural magic and the occult were fundamental components.

With his mouth closed in a vise to prevent him speaking, Giordano Bruno was burned alive. Amongst the heresies for which he was condemned to the terrible tortures of the Inquisition was his belief that "the universe is one, infinite, immobile." When his sentence was read out, the rebel monk is said to have shouted in the face of his accusers that he would die a martyr and willingly, and that his soul would rise up to heaven with the smoke. His books suffered a similar fate: they were ordered to be burned and put on the list of banned books.

A multifaceted genius and a complex renaissance philosopher and "sorcerer" figure, Bruno's philosophical theories held that the universe, in all its forms, was the manifestation of a single principle.

He conceived of a plurality of worlds similar to our own in a universe that was not created but had always existed. This idea was radically opposed to Christian theology.

He had the courage to keep to his own vision of the infinite cosmos despite the interrogations and the torture, which made him a symbol of lay thought against the dogmatism of the Inquisition.

His only crime was to have theorized the existence of the Multiverse and parallel realities before modern quantum physics.

"A day will come when man will awake from oblivion and finally understand who he really is and to whom he has ceded control over his own existence, to a false, deceptive mind that makes him and keeps him a slave… man has no limits and when one day he realizes this, he will be free here in this life," this quotation can be considered the inheritance Giordano Bruno has left us.

13 MICHELANGELO THE HERETIC

From the discovery of some previously unknown letters of the powerful cardinal Ercole Gonzaga, Michelangelo seems to be deeply involved with two great players on the European scene in those days: the English cardinal Reginald Pole and the noble Roman poetess Vittoria Colonna, two central figures in a clandestine militancy that marked the artist's life.

What linked these people together?

The key lies in those private letters.

There is mention of some images of Christ which Michelangelo circulated amongst these people. What is behind this exchange of drawings?

Gonzaga, Pole and Colonna were united by a mysterious affiliation. Michelangelo was their point of reference. Were they just art enthusiasts or is there something else in their connection with the artist?

Colonna, who belonged to one of Rome's most powerful families, was a friend of Michelangelo's. They both shared a strong religious passion, a spiritual search inspired by the ideas of the Protestant Reformation – ideas already considered subversive by the Catholic Church.

"And I've seen that divine grace cannot be bought and it is a great sin to keep it in discomfort," thus wrote Michelangelo in one of his letters to Vittoria Colonna. In these few words Michelangelo makes the same criticism as the Protestants of a Catholic Church in which the practice of selling people salvation for their souls was rife.

But what is the link between the art of Michelangelo and the ideological conflict of those years?

Precise meanings emerge from his various drawings. All are works centered around the figure of Christ, who was to return to the center of the spiritual life of a Church now far removed from the teachings of its founder.

The moral decadence of the church in those days was shocking. A circle of people, the Spirituals, formed around the charismatic figure of Cardinal Pole, one of the most powerful prelates of the day. They become a reference point for many in Italy. They passionately espoused a radical renewal of the Church. They saw Pole as a leader, the right man to clear up the conflict with the Protestants and guide the Church towards a new era of spirituality.

Michelangelo was close to this group, we might even say that he was a member of it, identifying himself completely with its theology: the idea that faith in itself is enough to guarantee salvation. An idea that struck the power of the Church at its heart. If a good Christian could commune directly with God, the mediation of the clergy was pointless and the stream of money they received from the

faithful to open the gate of heaven for them was illegitimate.

The orthodox fringe of the clergy was worried about this and tried their best to curb them.

Cardinal Carafa, the future Pope Paul IV, did everything in his power, persecuting the Spirituals by every means.

He saw Pole as his main rival to the papacy and the Spirituals as a dangerous force to be crushed.

Michelangelo felt the effects of this. Carafa sensed danger in his works.

The altar piece of the Sistine Chapel, depicting the Universal Judgment, was immediately deemed obscene and immoral because at the center of attention was man, not the Church. The cardinal threatened to destroy it.

Fortunately Pope Paul III defended the artist and preserved his masterpiece.

When Carafa was named inquisitor general, he couldn't openly attack Reginald Pole and the members of the Spirituals since they were still too powerful, so he opened a secret inquiry. He had them watched, intercepted their letters... he removed the preachers with the largest followings. Amongst these was Bernardino Ochino.

Carafa had him called back to Rome to justify what he was preaching. Fearing arrest, Ochino fled to Protestant Switzerland.

For Carafa it was a triumph.

Ochino wrote to his friend Vittoria Colonna: "I decided to flee since in Rome they wanted to reform the Church

starting with my death. Now I can remove my mask and speak the truth openly."

Pole advised Colonna to hand the letter over to the Inquisition in order to distance herself from her fugitive friend, a move that cost both of them dearly. Indeed this was the pretext for the inquisitorial repression of the entire group of the Spirituals.

Forced into hiding, they began to meet up secretly to have their manifesto, "The Benefit of Christ", printed. Although already widespread in handwritten form, the manifesto had a huge circulation. It was an enormous threat to the Church, which declared it heretical.

When Paul III died, Pole seemed destined to succeed him since he had been fingered by the pope himself as his successor. But Carafa turned up at the Conclave saying that he had proof of Pole's heresy, i.e. that he and Colonna were the suspected publishers of that diabolical tract.

This move knocked his rival out of play and eased Carafa's way to the papacy.

The Spirituals' dream of a new path for the Christian faith was swept away forever.

Once cardinal Carafa had been made pope, he cut off Michelangelo's salary, isolating the artist both socially and economically.

His personal drama was exacerbated by the loss of his friend Vittoria Colonna, who died in mysterious circumstances.

All the Spirituals were entered into the register of the Inquisition.

Are there any traces of Michelangelo's heretical passion?

There certainly are, just go to the Basilica of Saint Peter in Chains, so called because it houses the very chains the apostle Peter was imprisoned with in the ancient Mamertine Prison. In this basilica there is a very special tomb, that of Pope Julius II.

What has Michelangelo got to do with this funerary monument?

During the months when Michelangelo conceived the final design for the tomb, the Spirituals were at their point of greatest expansion in Italy.

The artist felt himself in danger. He tried to hide the true meaning incised in the marble of this work. The tomb itself had become a compromising element. That is why, in the official description of the work he gave to a young pencil pusher, he tried to remove any kind of allusion to the text of the Spirituals by giving misleading clues.

It is not difficult to find these inconsistencies if you observe the masterpiece and Michelangelo's own description of it.

Of all the statues, the two that stand out are those next to Moses.

The two female figures represent two ways of being, but also two paths to salvation: the Contemplative Life is represented by Rachael praying as if using only Faith to attain salvation, while the Active Life, represented by Leah,

finds salvation in something very interesting which is worth further investigation.

The statue depicting the Active Life has a strange object in its right hand. Michelangelo says that it is a mirror, but looking closely we can see that it is a torch... charity, which illuminates and makes explicit and visible the power of faith because it is faith and faith alone that can save you.

A devastating message that is the basis of the Spirituals' thought, that Michelangelo, fearing for his fate, wisely tried to conceal. An ambiguity handed down for centuries which the artist manages to pull off completely.

Then the laurel wreath is described as a garland of flowers. Why? How come no art historians have noticed these incongruities?

Turning now to the pope, Michelangelo depicts him small and defenseless, left in the shade by the mighty sculptures below.

This is not the pope the people knew, who was prouder than an emperor in life. Why did Michelangelo depict him so uncertain and penitent? Perhaps because in an ideal spiritual pathway it is man and his faith that are at the center of everything, with no need for papal mediation.

Moses holds another mystery. It is said that Michelangelo, at a certain point during the work, turned the prophet's face. We know that Michelangelo was capable of doing so: the Rondanini Pietà was left at an intermediate stage with Mary's face turned.

Originally, then, Moses was facing the altar and towards the relics of the chains, themselves a symbol of Catholic superstition.

All of a sudden, Michelangelo decided that he didn't like this pose anymore. Perhaps, disappointed by clerical corruption and the harsh repression meted out to the Spirituals, he decided to turn the prophet's gaze towards the exit, towards the light. His eyes seem to look around, searching contact with God. The horns on his head, typical of Moses' iconography (due to a translation error in Exodus, which recounts that Moses, coming down from Mount Sinai, had two rays on his forehead. The Hebrew karan or karnaim "rays" could have been confused with keren "horns"), in this sense, seem like two antennas helping in the search.

By making Moses look away from the altar, the artist reiterates the centrality of a direct relationship with God. He transforms a work designed to celebrate a pope into the Spirituals' political manifesto.

As we have seen, Michelangelo successfully tried to conceal these occult meanings. Thanks to his shrewd description, the tomb no longer communicates the ambiguous Lutheran message, but returns to being an orthodox monument.

Disappointed by his own cowardly behavior, Michelangelo, in a Pietà sculpture for his own tomb, depicted himself in the guise of Nicodemus, the man who visits Christ at night because he doesn't have the courage to love him openly.

In this final private sculpture, the artist manifests his incapacity to express his own faith in public and all the pain this pretence costs him.

UNKNOWN ROME

ABOUT THE AUTHOR

Francesca Brocchetta, a freelance journalist, has a degree in Linguistic and Philological Studies from La Sapienza University in Rome. She has worked with public and private bodies on tourism, culture and territorial development projects. A history and Roman art enthusiast, she has published with Polaris the book *Roma: misteri e itinerary insoliti tra realtà e leggenda* and *Isole Pontine*.

www.ingramcontent.com/pod-product-compliance
Lightning Source LLC
Chambersburg PA
CBHW021935170526
45157CB00005B/2325